IMAGES
of America

OXFORD

T0398540

IMAGES
of America

OXFORD

Hunter C. Gentry and Amy E. Henderson
Foreword by Mayor Alton Craft

ARCADIA
PUBLISHING

Published by Arcadia Publishing
Charleston, South Carolina

Printed in the United States of America

Library of Congress Control Number: 2021933266

For all general information, please contact Arcadia Publishing:
Telephone 843-853-2070
Fax 843-853-0044
E-mail sales@arcadiapublishing.com
For customer service and orders:
Toll-Free 1-888-313-2665

Visit us on the Internet at www.arcadiapublishing.com

This book is dedicated with great love and affection to my nieces and nephews—Beaux, Cora, Brayden, Jaxon, Hank, Sarah, and Teagan. It is my hope that everything you do in life is done with passion, love, and understanding.

—Hunter C. Gentry

Everything I ever do is dedicated to my family. My husband, Kenny, and children, Kenneth and Lily, are my everything. The community that this book is about is the home in which I now choose to raise my children.

—Amy E. Henderson

CONTENTS

FOREWORD

As someone who loves history, I am excited that Oxford's history has finally been accumulated into a book from which we can all learn. Hunter and Amy have done an excellent job compiling records of our city along with many important photographs that showcase Oxford's growth. Their journey was not an easy one. This has been a project that they have been working on for over a year, and they have accomplished for us something that has never previously been done.

In this book, you will be able to read about the city and the people whose contributions make Oxford one of the best places to live. Our community has weathered many storms, and you will be able to catch glimpses of our journey from the 19th century to the 21st. We have expanded by leaps and bounds for almost two centuries, and Images of America: *Oxford* will show you just how we have evolved and will continue to grow.

The future is bright for Oxford, and there will be many stories yet to be told.

—Mayor Alton Craft

ACKNOWLEDGMENTS

The research, writing, and photograph compilation for Images of America: *Oxford* has been a huge undertaking. It would not have been possible without the help of many individuals, especially Jeanna McEwen, assistant director of Oxford Public Library. Many of the photographs used in this publication have generously been offered by many individuals sharing images from their family collections, including Shirley Mellon Dewberry and Kathy Bentley Hall. Special thanks to Teresa Kiser and Shane Spears for their help in acquiring photographs from the Alabama Room and Russell Brothers Collection at the Public Library of Anniston–Calhoun County as well as Jim Johnson at Lance Johnson Photography. Lastly, a special thanks to David W. Hodnett for his encouragement and assistance with proofreading this publication in the early stages of writing.

Above all, this project would not have been possible without the funding and support from the City of Oxford mayor Alton Craft and council members Phil Gardner, Mike Henderson, Charlotte Hubbard, Chris Spurlin, and Steven Waits.

The images in this book appear courtesy of the following people and entities:

Alabama Department of Archives and History (ADAH)
Amanda Robinson (AR)
The *Anniston Star* (AS)
Charlotte Young Hubard (CYH)
Hunter C. Gentry (HCG)
Hartwell Masonic Lodge No. 101 (HML)
Kathy Bentley Hall (KBH)
Library of Congress (LOC-HABS)
Marilyn Lipscomb Clark (MLC)
Mary Kay Whatley (MKW)
Meadowbrook Baptist Church (MBC)
Nancy Cotton Burnell (NCB)
Nancy Locke Whitley (NLW)
Oxford Church of Christ (OCC)
Oxford Police Department (OPD)
Oxford Public Library (OPL)
Public Library of Anniston–Calhoun County, Russell Brothers Collection (PLACC-RBC)
Shirley Mellon Dewberry (SMD)
Temple University (TU)
Trinity Baptist Church (TBC)
Tom Collins (TC)
Tull C. Wigley (TCW)
Whittle Family—Burtie and Gay Whiteside Collection (WF-BGWC)

INTRODUCTION

Oxford is a beautiful area that drew early settlers to create a town that has grown through the years to include churches, schools, a college, and businesses. Some remarkable people called Oxford home, and their community was made better by their efforts. Long before incorporation as a city, this fertile land was the home to the Muscogee Creek Nation. From the early days of Lickskillet to the community's growth into a modern city, Oxford has continued to offer recreational, educational, and business opportunities.

This book will aim to give a history of Oxford and the lives its people have lived through the ages. The people who resided in this area were productive, shaping a unique community for their own and future generations. Many homes that were built as the community developed are featured in this book; some of them are still standing. Education has been a priority in Oxford since the beginning, as have community and religion. Recreation, too, has naturally grown as the people who built the town enjoyed the area.

With a location that lends itself to community-building, Oxford residents have always taken advantage of the area to build strong ties among themselves and their neighbors.

One

THE EARLY DAYS

The Muscogee Creek Nation has called the Choccolocco Valley home for 12,000 years. In 1540, Hernando de Soto crossed the region on behalf of Spain in search of riches. France claimed the lands in 1699 after successfully establishing settlements at Mobile, New Orleans, and Biloxi. Even though France controlled the area that would later become Oxford, it was still inhabited by the Creek Nation. England gained possession of the lands after signing of the Treaty of Paris at the end of the Seven Years War. In 1789, the entire northern portion of Alabama was owned by Georgia. The lands were given to the federal government in 1802 as part of the Mississippi Territory.

Alabama was admitted to the Union on December 14, 1819. Benton County was incorporated on December 18, 1832, and included present day Calhoun, Cleburne, and portions of Cherokee and Talladega Counties. At the time of incorporation, the only incorporated towns in Benton County were Jacksonville and White Plains. During the early 1830s, the Snow and Simmons families were two of the first families of European descent to settle among the Creek natives of the area. Snow owned the land south of present-day Choccolocco Street, and Simmons owned the land north of it. An early legend recalls that the southern area was called Skace Grease, and the area to the north was called Lick Skillet. Local folklore states that a traveler was passing through and needed a place for rest and food. As he was visiting a local, he was directed to "lick the skillet" because they were "skace of grease." The boundary line separating the lands was a creek that flows parallel to Spring and Snow Streets.

—Hunter C. Gentry

In the fall of 1831, Gideon Riddle traveled from Georgia to explore the area where Oxford is now located. At the time, the only settlers of European descent living there were the Dooran and Connor families. Riddle discovered many small Native American settlements along Choccolocco Creek from Talladega to Boiling Springs. Interpreter Billy Scott accompanied Riddle along the way to see a Native American woman living at Boiling Springs; there, she recalled the origins of Blue Pond. The image above is from an early postcard showing Boiling Springs. (SMD.)

Fleming Freeman purchased land at Boiling Springs and built his home on it in 1839. The location was prime due to the vast amount of natural resources and the trade between Calhoun and Talladega Counties. Thomas J. Caver purchased the property in the 1830s and established a farm; he was a merchant, landowner, and postmaster. (LOC-HABS.)

According to the 1860 US Census Slave Schedule, Thomas J. Caver owned 32 enslaved peoples and had a total of eight cabins on his 600 acres of property at Boiling Springs. At the end of the war, when the Emancipation Proclamation was signed into law, most—if not all—of the people enslaved by Caver remained on the property and in the surrounding community to tenant farm and sharecrop. The former Boiling Springs Methodist Episcopal Church that was located north of the property was given to the freed slaves to use as a place of worship and burial ground. (LOC-HABS.)

Dudley Snow was born in Virginia on December 25, 1803, to Thomas and Elizabeth Hale Snow. At a young age, he and his brother, Fielding Snow, moved to Roane County, Tennessee; in 1832, they migrated to Alabama. Fielding settled in Jacksonville, and Dudley settled in the area that would later become Oxford. The Snow brothers were attracted to the area due to the abundance and cheap price of land. Dudley owned all of the land south of Choccolocco Street. The Snow House is pictured here. (PLACC-RBC.)

11

Elisha S. Simmons, son of Elisha and Mary Lowry Simmons, was born between 1818 and 1819 in South Carolina. Elisha S. and his family moved to the area about 1832, the same time as the Snow family. Elisha was the first elected intendant (mayor) of Oxford and worked as a farmer and merchant. He owned the land north of present-day Choccolocco Street. Before moving to Lamar County, Texas, in the 1850s, he deeded the park at Main and Oak Streets to the town for use as a public park and wagonyard. The Simmons House is shown above. (OPL.)

Dr. Stephen C. Williams served as Oxford's first official mayor. He was born July 1, 1816, in Spartanburg, South Carolina, to Frederick and Martha Selman Williams. He moved to Oxford in 1845 to practice medicine. Williams also served as postmaster; attorney for the Selma, Rome, & Dalton Railroad; and deacon for Oxford First Baptist Church. (OPL.)

On April 23, 1865, Richard H. Lloyd, shown here, was working for Benjamin Clark at his mercantile store as Union soldiers were traveling through the area on their way to destroy the Oxford Iron Works and railroad station at Blue Mountain. Clark shot at the troops, and Lloyd was captured. Lloyd was given a chance to run, and the soldiers shot and killed him. He was buried in an unmarked grave at the city cemetery. (OPL.)

Due to an influx of families migrating to the area, it was important that a post office be established in the community. The first post office was located at the home of Dudley Snow. In 1849, the name of the post office officially changed from Snow's Creek to Oxford. On February 7, 1852, the town of Oxford was incorporated by an act of the Alabama State Legislature. Stipulations of the incorporation included a certain number of council members, an intendant (mayor), and the limits appropriated within a certain distance from the male academy. It is not clear if the name Oxford was chosen due to the oxen that were brought to ford the creek or if someone suggested it based on the Oxfords in Mississippi and Georgia or Oxford, England. (OPL.)

On February 21, 1860, due to the division and name change of Benton County to Calhoun County, Oxford petitioned for a second incorporation. The town was required to elect seven council members and an intendant and to redraw the limits from a half mile from the railroad culvert. After construction of the railroad and Oxford Iron Works, Oxford saw an increase in population and commerce. For decades prior to the Civil War, the economy was primarily based on self-sustaining agriculture and trade. The people deeply believed in education, faith, and family values. During the Reconstruction period, Oxford boomed with a bustling economy in the cotton trade. (OPL.)

Samuel C. Kelly and his brother, James S. Kelly, were the first to operate a livery business in Oxford. The Kelly brothers, who were natives of Franklin County, Tennessee, came to Benton County, Alabama, in the 1830s and settled in the Alexandria Valley. They eventually made their way to Oxford and became involved in the community due to its thriving business trade. The Kelly Livery was located at the corner of Main and Snow Streets. Samuel served in the Mexican War and Civil War and worked his way up to captain while in the Confederate Army. He was the paternal grandfather of Maud McLure Kelly, the first female to practice law in Alabama. James surveyed Texas during its bid for statehood in 1845, served as justice of the peace, and was known as "Sam Slim" for his columns in the *Hot Blast* and *Weekly Times*. (OPL.)

The business community of Oxford in 1885 included a number of general merchandise stores, hardware stores, livery stables, grocery stores, a shoe repair shop and cobbler, a millinery shop, a dry goods store, a tin shop, drugstores, jewelry stores, a bank, a post office, harness and carriage shops, a freight depot, three churches, a hotel, and a Masonic lodge. In most cases, there were multiple hardware, grocery, and dry goods shops. The economy of the Reconstruction-era Oxford thrived thanks to the business of traders from across the region. (OPL.)

An article in the *Jacksonville Republican* dated March 21, 1885, stated, "Oxford is rapidly coming to the front and will soon lay aside her village vesture and don the robes of a metropolis." The population included 1,500 residents. In February of the same year, the state legislature passed an amendment to the 1860 charter of Oxford to change the mayoral and council election from the first Monday in March to the second Monday in March. On March 9, 1885, the citizens of Oxford held a vote with a total of 190 votes cast. Results of the election were in favor of Dr. John B. McCain (with 93 votes) and Charles T. Hilton (with 92 votes). The council members elected were Joshua Draper Jr., John B. Ingram, L.C. Humphries, Tilman A. Turner, Xerses H. Bagley, and Oliver W. Cooper. Due to the closeness of the vote counts for McCain and Hilton, McCain resigned, and another election was scheduled for the following Monday. Since records were not adequately taken, the results of the second election are not known. (OPL & ADAH)

Two

RESIDENCES

The first home in Oxford was built by Dudley Snow in 1832. Shortly after, more families settled in the community, and more homes were built. Oxford was founded by hardworking farm laborers who lived in simple yet comfortable dwellings. Many of the early homes began as single-room cabins and later evolved into dogtrot-style dwellings. The evolution of the home happened as the owner obtained more wealth, which ultimately resulted in the addition of rooms and ornamental embellishments. This process can be seen especially with the changes of the Dudley Snow House, Gunnels-Wingo House, and D.C. Cooper House. Today, there are less than 15 homes in Oxford that were built prior to the start of the Civil War. A handful of homes were built during the 1870s, when locals regained their wealth after losses of the war, and an influx of carpetbaggers migrated to the area. A majority of the homes in Oxford were built between 1880 and 1920. The largest residential areas are on Main Street, McPherson Street, Gray Street, McKibbon Street, and Second Street. Of the homes still standing, five are listed in the Alabama Register of Landmarks and Heritage, and one is listed in the National Register of Historic Places. Notable architectural styles of the homes include Greek Revival, Colonial Revival, Gothic Revival, Queen Anne, Victorian, and Craftsman.

—Hunter C. Gentry

This home was built in 1832 by Dudley Snow as a one-and-a-half-story dogtrot with rooms on each side of an open center hall. Later modifications included shed rooms at the front and rear. The Snow house is the oldest standing home in Oxford. Snow and his family were the first settlers of European descent in the area. In the 1960s, George Mizzell and Myra Farmer Mizzell purchased and extensively restored the home. Myra Mizzell is a direct descendant of Snow. Due to the expansion of the Quintard Mall in the 1990s, the home was relocated a few miles south of town. This home is listed in the Alabama Register of Landmarks and Heritage. (LOC-HABS.)

This Boiling Springs home was built in 1839 by Rev. Fleming Freeman. Freeman, a Georgia native, was a wealthy planter who settled in the area in the 1830s. Freeman was the brother-in-law of William Wyatt Bibb, Alabama's first governor. The land on which the home is situated was the prime location for the establishment of an antebellum plantation due to the natural resources and the convenience of its location between Talladega and Calhoun Counties. The thousands of acres surrounding the property had been inhabited by Native Americans since the first Ice Age. The Federal architectural style of the home and outbuildings was significant enough to be photographed and documented by the Historic American Buildings Survey (HABS); in 1934, the Historic Sites Act was passed by Congress to give out-of-work architects jobs documenting "American antique buildings." (LOC-HABS.)

It has been rumored that this home was originally a one-room cabin that was later modified to be a dogtrot style home, and the upper levels were added later. Thomas J. Caver purchased the property and established his farm in Boiling Springs in the 1840s. Caver was a planter, merchant, and postmaster. After the Civil War, many of Caver's former slaves continued to live on and farm the lands surrounding the property. After the death of Caver, the property was passed along to his daughter Augusta Caver Smith and her husband, Capt. John F. Smith. In 1943, Harry Glen Davis and his wife, Ruth Quick Davis, purchased the property and established their farm there. Ruth was later known for her very festive and showy Christmas displays. In 2011, the home was destroyed by vandals and arsonists. (LOC-HABS.)

This McPherson Street home was originally constructed as a one-room cabin between 1845 and 1850. Today, the house is one of Oxford's few antebellum dwellings that exemplifies the architectural vernacular "I-House" with a few Victorian modifications throughout. Prior to 1868, the E.G. Robertson and Mary Stamps Robertson family resided in the home. The Borders, McCord, and Watson families have lived in this home. (OPL.)

This Main Street Greek Revival home was built in the 1850s by Dr. Stephen C. Williams. A South Carolina native, he came to the area that would later become Oxford in 1845 and served as one of the town's earliest mayors and physicians. The home was later owned by his son Dr. Benjamin D. Williams. The lower level of the home was used for his office, and the upper level was used as the family's residence. In the early 1960s, the home was demolished for construction of a new post office. (OPL.)

This Snow Street home is a center-hall plan featuring modified Greek Revival architecture with early Victorian characteristics. The oldest portion of the home appears to be the rear rooms, which were constructed about 1860. The home was owned by the Zedekiah H. Clardy family in the 1870s. Clardy was a widely known and talented brickmason who constructed many notable landmarks in Calhoun and Talladega Counties. The Yoe and Stewart families have also resided here. The home is listed in the Alabama Register of Landmarks and Heritage. (HCG.)

This Gray Street home is significant due to its Greek Revival architecture and few modifications to the exterior since its construction around 1855. In the 1870s, John Graham and Elizabeth Calloway Graham resided in the home with their family. John Graham was a North Carolinian by birth and migrated to Calhoun County in the 1830s with his family. He was a merchant and a member of the Baptist church, and he served as an alderman during his time in Oxford. The Toland and Hand families have been residents of the home since before 1900. (OPL.)

This Ross Street home was built between 1867 and 1870. The style of the home is a mixture between late Federal and early Greek Revival. Gen. Albert H. Ross was one of the first owners of the home. Ross, a Tennessee native, came to Oxford after the death of his wife in 1859. In the early 1900s, Jessie F. Clark bought the home and raised his family there. In 1943, Jessie's daughter Ruth Clark Conolly purchased the home. During the years since, many rooms in the home were rented to young couples and individuals. In 2020, after decades of neglect and vandalism, the home was torn down. (AR.)

This Oak Street home was built in 1870 by Daniel P. Gunnels. It has been rumored that the center hall and lower level portions were built much earlier, before the Civil War. The home is one of a handful remaining in Oxford constructed in the Gothic Revival architectural style. Gunnels moved to the Boiling Springs community, east of Oxford, and cooperated a mercantile business with Thomas J. Caver. In the 1860s, he established D.P. Gunnels & Others. The Gunnels Building was the first brick structure in Oxford located at the corner of Main and Choccolocco Streets. The exterior woodwork was added sometime after 1900. The home was later purchased by the Wingo family. It is listed in the Alabama Register of Landmarks and Heritage. (PLACC-RBC.)

This Choccolocco Street Colonial Revival home was built in 1870 by Dr. Elbert H. Allen. Dr. Allen, a South Carolina native, came to Oxford in the early 1850s. He served as a physician and a member of the Alabama House of Representatives. His father, Matthew Allen, was also a member of the Alabama House of Representatives that, in 1852, brought forth the bill to incorporate Oxford as a town. The home is constructed of stamped concrete to give the appearance of stacked blocks. This home is still owned by descendants of Dr. Allen. (OPL.)

This Oak Street home was built in 1870 by E.G. Robertson. This is one of three houses in Oxford that exemplifies a modified Gothic Revival style, which is most notable for the high-pitched gable. Robertson was a Civil War veteran who served in the Confederate Army and a well-do-to mercantile businessman during the Reconstruction era. This home was later owned by Earl Clark and the First Baptist Church of Oxford. (OPL.)

This Main Street home was built in 1870 by Rev. Elijiah T. Smyth. The architecture of the house exemplifies the unusual Italianate style of the post–Civil War South, notably because of the shallow hipped roof and decorative eave brackets and woodwork on the front porch. Reverend Smyth, a South Carolina native, served as a circuit minister, preaching at churches around the area including the First Baptist Church of Oxford. This home was later owned by the Draper, Kerr, and Strickland families. (OPL.)

This Gray Street Greek Revival home was built in 1870 but has been rumored to have been built much earlier, before the Civil War. In 1889, Luther Patillo, an Autauga County native, purchased the home and property for the purpose of his children being able to attend Oxford College. Patillo is the maternal grandfather of former First Lady Claudia "Lady Bird" Johnson. The home was later owned by the Staples, Houston, and Lindblom families. It is listed in the Alabama Register of Landmarks and Heritage. (OPL.)

This Main Street Colonial Revival home was built in 1875. It features characteristics of Stick Style architecture, including the jerkinhead roofline and dormers. In 1900, the home underwent an extensive renovation and modernization with the installation of indoor plumbing and electricity. Mamie Merritt Constantine, widow of Dominique F. Constantine, owned the home until her death in 1946. The home was later owned by the Norton and Ward families. (OPL.)

This Gray Street modified Italianate home was built between 1875 and 1880. William F. Gray, a native of Randolph County, lived in the home in the early 1900s. Capt. John F. Smith, grandfather of Mayor Hemphill G. Whiteside, and his family lived in the home during the winter months. Neoclassical modifications to the portico and front entry were added in 1915. The home was later owned by the Pinson family. (PLACC-RBC.)

The Snow Street home was originally believed to have been built between 1875 and 1880, but recently discovered records indicate that it was built around 1854 by a Mr. Castleberry. The architectural style of the home is one-of-a-kind to Oxford, exemplifying a modified Italianate raised cottage. The home was later purchased by Hemphill and Burtie McLain Whiteside. Whiteside served as Oxford's mayor from 1944 to 1960. During the transition of city hall locations from Main Street to Choccolocco Street, city business was conducted in a room at the lower level of the home. (OPL.)

This College Street home was built in 1880 by Zedekiah H. Clardy. The style of the home is modified Queen Anne Victorian constructed of locally handmade bricks. From the time of its construction until 1895, the home served as a boardinghouse for professors and students of Oxford College. It has been rumored that Ruth Elder—aviation pioneer, actress, and native of this area—lived in the home while attending Calhoun County High School. The Bagley and Billingsly families have since occupied the home, which is listed in the Alabama Register of Landmarks and Heritage. (OPL.)

This McKibbon Street home was built between 1880 and 1900. The style is a mixture of Colonial Revival and Italianate with later Craftsman modifications. The Urquhart and Bentley families have been residents of the home. (OPL.)

This Main Street Queen Anne home was built in 1880 by Charles J. Cooper. Cooper, a native of South Carolina, came to Alabama before 1850. He was one of the largest landowners of areas in Oxford and present-day Anniston. Cooper established C.J. Cooper & Sons as the first wholesale grocery in Oxford; it was located on Main Street. He was also in the banking business before consolidating with the Draper banking firm that, in 1888, changed its name to the Bank of Oxford. The Cooper family often gathered to celebrate Christmas, as shown in this photograph from Christmas Day in 1896. The Phillips family have also been residents of the home. (TCW.)

This Barry Street home was built in 1883 by Capt. Thomas Barry. The construction of the home was significant enough at the time it was built to warrant a mention in the local newspaper. Originally, the home featured detailed elaborate woodwork along the porch. The style of the architecture is Italianate. Barry, an Ohio native, came to Oxford in 1873 and worked as a successful merchant. (OPL.)

This Main Street home was built in 1883 by Charles J. Cooper for his daughter Mary Cooper Reed. It is rumored that two rooms of the home were constructed prior to the Civil War and later modified to a Queen Anne style. After the death of Mary Cooper Reed, Walter and Vanessa Stephen purchased the home in 1935. Stephen worked as a research scientist for Monsanto Chemical Company and was chief of the Oxford Fire Department. The Williams and Hammond families also have been residents of the home. (OPL.)

This McPherson Street Queen Anne home was built in 1884 by Oliver W. Cooper, the son of early Oxford settler and merchant Charles J. Cooper. Oliver was a cotton and dry goods merchant, council member, and founder of the Oxford Christian Church. In 1951, the home was sold to an Anniston rental firm, and the house was modified into four apartments. In August 1955, the structure was destroyed by fire. (KBH.)

This McPherson Street home was built in 1885 on property owned by Clark Snow. It has been rumored that a portion of the home was built before the Civil War. The architecture of the house exemplifies an Eastlake Queen Anne cottage. Rev. William A. Hall and his family lived in the home. After he moved to Virginia to serve as pastor at a Presbyterian church, his sister Mary Hall Grogan and her husband owned the home. The Simmons, Bibb, Pirkle, and Bedford families have also resided in the home. (OPL.)

This Choccolocco Street home was built in 1887 by J.T. Moye. Moye and his brother were in competition with one another regarding who could build the best house. The architectural style of the home best exemplifies a high-style Victorian Queen Anne, featuring a top Romeo and Juliet balcony, and is constructed of locally made bricks. In 1901, the home was sold to George W. Eichelberger, proprietor of local clay molding works and mayor of Oxford. A short time later, in 1911, William E. Mellon purchased the home and raised his 10 children there. The Mellon family owned and operated the Mellon Apple Orchard that was located near the Sunny Eve community (presently known as Cider Ridge Golf Course). During the time of the Mellon family's occupancy, they hosted many family reunions and gatherings in the home and on the surrounding grounds. Beginning in the 1930s, sisters Betty and Nell Mellon operated the Mellon Tourist Home, where rooms were rented to travelers. Due to an increase in the availability of motels, the Mellon Tourist Home closed in 1955. (PLACC-RBC.)

This Second Street home was built in 1887 by Clark Snow, son of early settler Dudley Snow. The home displayed Oxford's least-altered style of late Victorian architecture. Clark Snow was a successful buggy salesman. (OPL.)

This McKibbon Street home was built in 1895 by James R. Landham. The style of the home is Queen Anne with Colonial Revival characteristics. Landham worked in the saddle and harness business for a number of years. In 1900, the home was sold to Frederick C. Moorefield; during that time, the upper level of the home was completed, and the staircase was added. Moorefield attended Oxford College and later opened a jewelry business in Anniston after relocating there. The home most notably features a rounded portico and dormer porch. The Smith, Anderson, Gray, and Taylor families have also owned the home. (OPL.)

This Queen Anne Victorian on Main Street was built in 1895. The most recognizable feature of the home is the single-story rounded turret topped with a copper finial. Frank Butenschon lived here with his family for a number of years. Butenschon was one of the organizers of the Oxford Chamber of Commerce and served as city clerk under Mayor Davis C. Cooper. He was the owner and operator of Butenschon Drug Company for decades. (OPL.)

This Main Street home was built in 1911 by Davis C. Cooper at the site of an earlier home. The style is a mix of Colonial Revival and Georgian Revival. In 1925, the home was modernized with indoor plumbing and electricity. The interior retains many original features from the 1920s renovation. Perhaps most unusual about the house are the box ball alley and handmade primitive gazebo constructed with native trees and branches. Cooper served as Oxford's mayor from 1910 to 1929. The home was later owned by the Campbell and Smith families. The house and its outbuildings are listed in the Alabama Register of Landmarks and Heritage and the National Register of Historic Places. (PLACC-RBC.)

Three

SCHOOLS AND CHURCHES

Churches and schools are an integral part of life in any community. Churches have been active in the area since the 1830s, when the Oxford Methodist Episcopal Church South (now the First United Methodist Church) and the Friendship United Baptist Church (now the First Baptist Church Oxford) were formed; Oxford Presbyterian Church (now Dodson Presbyterian Church) was established in 1856. Through the years, several other churches were organized in the area for various Christian denominations. Academies (male and female) have existed in the area since the 1840s.

The Public Education Act, passed by the Alabama Legislature in 1854, established the Alabama State Department of Education. This aimed to bring education, along with trained teachers and established standards, to all parts of the state. Funding and administrative offices were also provided as part of the bill. This encouraged communities across Alabama to evaluate the local educational opportunities that were available.

Citizens concerned about education in the community met in 1867 on the grounds of the Presbyterian church. This meeting resulted in the creation of a committee charged with founding a college for higher education in Oxford. While a suitable building was constructed, the Presbyterian church agreed to allow the use of its facilities. In June 1868, an octagonal two-story building was erected using brick made of clay from local grounds, and Dr. John Dodson became president of the school, which was called Oxford Male and Female College and chartered in 1871.

In the 1880s, the elementary department became a public school. The building was sold to the city of Oxford to house a public high school in order to comply with the High School Act passed by the Alabama legislature in 1907, which required the establishment of a high school in each county in the state. The campus was then expanded in 1911 and used by Calhoun County High School (and later Oxford High School), although the original building was razed in 1953. A new Oxford High School building was completed in 1951; at that time, Oxford High and the grade schools were still affiliated with the Calhoun County school system. In 1970, the Oxford City School District was founded as an entity independent of the Calhoun County system.

—Amy E. Henderson

The Male Academy on Second Street served young men in the community in the 1840s and 1850s. References to the academy appeared in advertisements in the *Jacksonville Republican*. The property was later purchased by the Mitchell family for use as a residence. After many years of neglect and vandalism, it was torn down in 2017. (OPL.)

The Coldwater School was established around 1895. A mention in the *Anniston Star* in February 1905 stated, "There will be a spelling bee at Coldwater School house next Friday between Taylor's Chapel and Coldwater, after which Professor Persons will make an address." (PLACC-RBC.)

Lucious L. Allen donated the land for the building of the DeArmanville School, which was erected in 1861. It was replaced in 1873 with a white frame building (pictured) which was located on the hill behind the present-day school. This structure burned down in 1916. The school was part of the Calhoun County school system for much of its history, though it is now part of the Oxford City School District. (PLACC-RBC & MLC)

Also part of the Calhoun County school system, the Friendship School was established before 1900 by John M. Snow. In 1953, the present building was constructed for students. In 1971, the Calhoun County Board of Education voted to close the school and sell it, and around 1995, it was renovated to become the Friendship Community Center, part of the city of Oxford's Parks and Recreation Department. (PLACC-RBC.)

Mae Waddell was a popular teacher at Trinity School in the 1910s. Ruth Dodd Butenschon, wife of Frank Butenschon, owner of Butenschon Drug Company, also taught at Trinity School in the 1920s. (PLACC-RBC.)

Dr. John William Abercrombie is a noted graduate of Oxford College. He went on to serve as president at the University of Alabama and superintendent of education of Alabama. Abercrombie also served in the Alabama Senate and the US House of Representatives. After leaving Congress, he became acting secretary of the US Department of Labor. Fellow Oxford College graduate Harry C. Gunnels filled Abercrombie's unexpired position as state superintendent of education. (OPL.)

The 51st Alabama Cavalry mustered into service 1,300 men by Col. John T. Morgan; Miss Todd, Abraham Lincoln's sister-in-law, presented the regimental flag. The large tree under which Morgan gathered his men became known as the Morgan Oak. It was on these same grounds that the building committee decided to place the Oxford College using the Gothic Revival architectural style. The Morgan Oak remained on the property until it was destroyed by fire in 1923. It is now the site of the historical marker that commemorates the site of the Oxford College. (OPL.)

This is the Oxford College class of 1889. Elbert Tull Allen is on the right in the second row; Allen was the son of Dr. Elbert H. Allen, an early physician in Oxford. (TCW.)

The Oxford College class of 1893 is shown with Professor Stephenson. Members of this class included W.W. Harris, Palmer McDiarmid, Allan Smyth, James Davis, Houston Davis, ? Aikens, Josie Wilson, Anita Parker, Margaret Licon, Mittie Roberts, and Alice Roberts. (PLACC-RBC.)

The Oxford College class of 1896 is shown here. Members of the class included Hugh Merrill, Nora Newsome, Guice Newsome, E.E. Gordon, Dudley Casey, Katherine Wilson, and U.K. Hedgworth. Of particular historical significance, Hugh Davis Merrill (1877–1954) served as the 12th lieutenant governor of Alabama from 1931 to 1935. He was the youngest member elected to the Alabama House of Representatives, in which he served from 1923 to 1931 and 1939 to 1943; he also was speaker of the house in 1923 and 1939. (PLACC-RBC.)

The Oxford College football team is pictured in front of the exterior of Oxford College in 1899. Members of the team included Mr. Wright, Hamp Draper, Mr. Borders, Mr. Wells, Mr. Crow, Paul Eichelberger, Mr. Clark, and Wally Bullard. In an *Anniston Star* article recalling the history of this photograph, the writer stated, "Bullard gained national fame later at Auburn when he combined with the Tiger fullback to pull a play, later declared illegal. The play consisted simply of the big fullback grabbin' Bullard by the seat of his pants and throwing him over the opposing line." (PLACC-RBC.)

Pictured from left to right at the dedication for the historic marker of Oxford College are Nannie Smith Whiteside, Ada Thompson Vann, and Rosa Wilson. All three ladies were graduates of Oxford College. (OPL.)

142 Reasons For Voting the Three Mill Tax.
There Are and Will Be Many Others---Give Them a Building.

In 1920, parents and leaders of Oxford decided to take action, establishing a mill tax to raise funds for the construction of an elementary school. It was determined that a mill tax would take 20 years to raise the appropriate money. In place of the mill tax was the organization of a Loyal Loan School League headed by a committee consisting of Robert A. Hingson, Sion W. Pace, and Davis C. Cooper Jr. The Loyal Loan School League sold bonds to patrons of the community to pay for the construction of a new school. The bonds held interest at a rate of six percent and were financed by the First National Bank of Oxford. (TCW.)

On April 5, 1921, Oxford Loyal Loan School opened as the first privately owned public school, housing first through sixth grades. The school was located at 100 Choccolocco Street, the previous site of a cotton warehouse. The total cost of the building was $40,000. The main floor of the building consisted of classrooms and offices, the basement held the school cafeteria, and the second floor was the auditorium. Some years later, the Calhoun County Board of Education purchased the school and changed the name to Oxford Elementary School. (OPL & TCW)

Due to deplorable conditions and overcrowding, the City of Oxford purchased Oxford Elementary School from the Calhoun County Board of Education in 1951 at a cost of $29,600. First through eighth grades were moved to Fulton Hall, which was located behind the newly built Oxford School on the site of the old Oxford College. (KBH.)

Gen. Tom Thumb was the stage name of Charles Stratton, a famous performer who traveled with P.T. Barnum. His wedding to Livonia Warren Bump was attended by over 10,000 people, and the couple was received by Pres. Abraham Lincoln at the wedding reception. Stratton and his bride were both little people, and their wedding, which was quite a sensation, inspired others around the country to have mock weddings with children acting as the bride, groom, and wedding party. (SMD.)

Calhoun County High School stood firm through a depression and two world wars. Schools around the state threatened to close in 1932 due to funding cuts enacted by the state legislature due to the Great Depression, but the teachers accepted IOUs or certificates for pay throughout that year in order for the school to stay open. In 1934, funding was again reduced by the legislature, but Calhoun County High School stayed open because students paid a nominal fee to attend. At the start of the 1936 school year, a new principal, H.T. Stanford, was installed and brought a largely new faculty with him. Enrollment continued to grow, and various rooms throughout the school were repurposed as classrooms. A residence was converted into a home economics department. Older campus buildings in disrepair were razed in the late 1940s to make room for new construction, which began on May 17, 1950. The original building was razed in 1953 as the new, modern Oxford High School began to serve Oxford students. (OPL.)

Football is a long-standing tradition in Oxford. These photographs show the Calhoun County High School team in the 1930s and 1940s. In the summer of 1934, under federal funding, the Works Progress Administration (WPA) constructed a stadium for the school that could hold 1,500 spectators (below). The stadium was listed in the Alabama Register of Landmarks and Heritage in 2000. (PLACC-RBC & SMD.)

The Calhoun County High School Basketball team is shown here in 1937. Pictured are, from left to right, (first row) Van Gene Nelson, James Dickenson, John Sprayberry, Ralph Emerson, and Cole Kirby; (second row) coach Newt Godfrey, Henry Buford, Jesse Williams, Howard Paris, Sam Snow, and principal H.T. Stanford. (PLACC-RBC.)

This image shows Calhoun County High School students on the grounds in the 1940s at the start of classes. The home of George Rutledge, located at the corner of Stewart and Second Streets, is visible in the center background. (SMD.)

These students are pictured in front of Fulton Hall at Calhoun County High School in the 1940s. Fulton Hall, named for H.C. Fulton, was constructed in 1930 as an auditorium and gymnasium at a cost of $15,000. Fulton Hall had a capacity of 1,000. (SMD.)

Members of the Calhoun County High School cheerleading team are shown in this portrait from the later 1930s. Members of the team included, from left to right, Jimmy Curry, Jane Eichelberger, Nell Howle, Geneva Shaddix, and Billy James. (PLACC-RBC.)

Construction began on a new building for Oxford High School on May 17, 1950. In 1951, the completed building welcomed students to its 29 classrooms and administrative rooms, a library, and a clinic. During the first year in the new building, over 950 students were enrolled, and 115 students received diplomas in the first graduating class at the new school. (PLACC-RBC.)

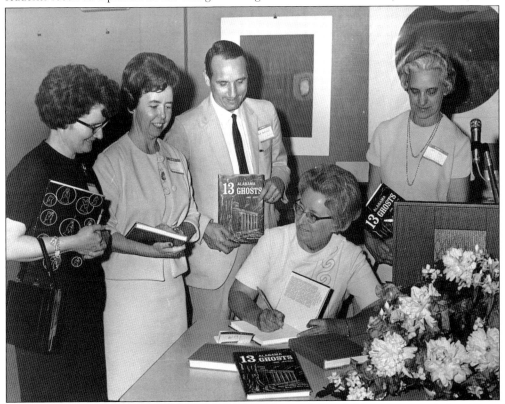

Oxford High School librarian Juanita Miller Rice (second from left) is shown with Joy Albea, Robert Schalau (director of Anniston's Liles Memorial Library), and Naomi Cox attending a book signing of *13 Alabama Ghosts and Jeffrey*, by Kathryn Tucker Windham, in May 1970. Windham is a famed Alabama folklorist and writer. (PLACC-RBC.)

The First Baptist Church of Oxford was organized at the home of Benjamin Mattison in March 1836 as the Friendship Church. In 1841, a log meetinghouse was constructed for services. Due to an increase in membership, Elisha S. Simmons donated land for the construction of a new building in 1860. In March 1910, construction commenced on a new brick church to the east of the former building. Lakeview Baptist Church, Blue Springs Baptist Church, and Meadowbrook Baptist Church were established as missions of First Baptist. (SMD.)

The Pioneers Sunday school class taught by Robert A. Hingson Sr. is pictured here in July 1922. Members of the class include Joe Black, John Watson, S.T. Hudson, Willie Lapier, Fermer McCullough, Williams Gaines Mellon, Jim Poore, Hugh Dodgen, Elmer Little, Charles Reiginger, Verner Scott, F.C. Knighton, Fay Roberts, John Kyle Abernathy, Melton Sharp, Tull Allen, William Crunk, George Edward Rutledge, Albert Carter, Dewitt Garrett, Mark Williams, Robert Hingson Jr., Guy McDowell, Arthur McNeil, and James Monroe Hingson. (TCW.)

First United Methodist Church was first erected around 1840. The original building—a hand-cut wooden board church with shutters—no longer exists, but the current building, erected in 1875, stands on the same grounds on Snow Street. The current church is of Normanesque architectural design with oversized handmade bricks. It has tall, round-arched windows and drip cornel cornices; the building is topped with a copper-sheathed dome and an iron weather vane. (PLACC-RBC.)

A baby show was organized by the Ladies Aid and Missionary Society of Oxford Methodist Church in May 1901. Participants included children from ages one to five. Merchants and business-owners were tasked with contributing prizes for the winning children. Each entry in the contest required a 10¢ fee to benefit the society. (PLACC-RBC.)

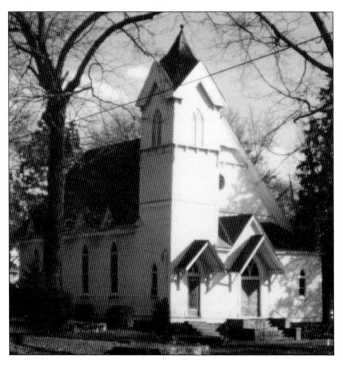

In 1856, a group of 11 met under the leadership of Rev. R.A. Houston to organize a Presbyterian church at Oxford. In 1857, John M. Forbes oversaw the construction of a church. It has been rumored that the church was part of the Underground Railroad. In 1891, the church underwent renovations to add modified High Victorian architecture with Gothic elements. Soon after the renovations were finished, lightning struck the bell tower and caused a fire. In April 1919, the church members voted to change its name to Dodson Memorial Presbyterian Church in honor of Prof. John L. Dodson. (SMD.)

In 1886, Trinity Baptist Church was organized in the community between Oxford and Coldwater. In 1953, a new building was constructed for worship, and a dedication service was held in June 1954. Due to an increase in membership, the building was expanded in 1967 under the leadership of pastor Rev. Lamar Rosser. (TBC.)

Oxford Christian Church was organized by members of the First Christian Church of Anniston as a Sunday school and church with 20 members on May 2, 1897. The church was built on Choccolocco Street. After construction of the Oxford campus, 15 members of the Anniston congregation joined. In 1919, William Ross Lloyd ministered to both the Anniston and Oxford churches. (OPL.)

Sunny Eve Baptist Church was organized after a 1935 revival held on the farm of Rev. R.A. Riddle. The first meetings of the congregation were held at the Jamback School. In 1940, land was given by the Jones and Mellon families for construction of a one-room wooden church. In the 1950s, the present building was constructed east of the original church. (MLC.)

Lakeview Baptist Church was organized as a Sunday school in August 1934 at Oxford Lake by members of local Baptist, Methodist, and Presbyterian congregations. On May 9, 1935, Lakeview voted to affiliate with the Baptist church. The original church was constructed in 1936 on Central Avenue. In 1952, construction began on the present building; it was completed in 1954. In the early 1960s, the congregation helped establish the Golden Springs Baptist Church. (HCG.)

Oxford Church of Christ was established in April 1940 with families of Oxford and members of the Sixteenth Street Church of Christ and Noble Street Church of Christ in Anniston. Services were held at the former Oxford Christian Church. In 1944, a brick church was constructed on Choccolocco Street. In September 1977, the congregation constructed a new building for worship on Hamric Drive. The former Oxford Church of Christ was purchased by the City of Oxford for use as a public library. (OCC.)

Meadowbrook Baptist Church was organized as a mission of Oxford First Baptist Church in 1957 and constituted as a church on April 24, 1960. Rev. Don Phillips served as the first pastor. (MBC.)

Four

Industry and Commerce

For generations, Oxford's economy was based on an agrarian society of self-sustaining farmers. The Oxford Iron Company began shortly after the construction of the Alabama & Tennessee River Railway from Talladega to Blue Mountain. In the 1870s, the cotton trade boomed, with Oxford serving as a regional hub for planters. The Blue Springs Cotton Mill became Oxford's first successful industrial corporation. At one time, the downtown commercial district had several drugstores, mercantile stores, millinery shops, furniture stores, hardware stores, a theater, warehouses, and a funeral home.

The first tracks of railway in Alabama were laid in 1832 in the Muscle Shoals region. New economic opportunities emerged after the construction of the railroad. The railroad stimulated the growth and development of nearby towns and communities as the transportation of goods and people became much more efficient. In 1848, the Alabama & Tennessee River Railway was created. The first tracks connecting Talladega to Oxford were completed in 1861, and a depot was completed soon after. Completion of the railroad meant economic growth for Oxford. In 1866, the railroad was consolidated and renamed the Selma, Rome & Dalton Railroad. In Oxford, the railroad was used to aid the Confederate Army in delivering products produced by the Oxford Iron Company during the Civil War.

The Oxford Iron Company was organized as a private corporation in November 1862 for the purposes of manufacturing iron to aid the Confederate Army. The land for the company was purchased from Daniel P. Gunnels and included 825 acres in present-day Anniston near Fourth Street and Wilmer Avenue. The furnace was built of cut sandstone native to the area and situated on 10 to 15 acres of flat land. A natural spring flowed directly to the furnace for continuous production of a maximum of 20 tons of iron daily. The final product was shipped directly to Selma via the Alabama & Tennessee Railroad.

In April 1865, under the direction of Gen. John T. Croxton, Union troops burned the furnace to the ground during a raid to seize and destroy anything that would aid the Confederate Army. The depot and railroad at Oxford were destroyed by raiders during the Civil War. In 1881, the railroad was sold to the East Tennessee, Virginia & Georgia Railway. A new depot, topped with a cupola, was constructed at the Oxford depot's former site in 1883.

—Hunter C. Gentry

SOUTHERN MILLS
CORPORATION
OXFORD · ALABAMA

The Blue Springs Southern Cotton Mill, designed in the likeness of a European castle in the Gothic architectural style, was built in 1885 by James B. Draper and Oliver W. Cooper. The community worked together to raise $50,000 for the construction of the mill. Blue Springs Southern Cotton Mill also developed a mill village, which included a street lined with homes for its employees

and their families, a schoolhouse, a water tower, and a warehouse. A nearby spring provided a water source for steam-powered production. The spring is fed from the same source as Oxford Lake and Blue Pond. (OPL.)

For many decades, Blue Springs Southern Cotton Mill was the primary textile industry in Oxford, producing rope, twine, yarn, maps, cotton sheeting, and other specialty products. In 1896, owners James B. Draper and Oliver W. Cooper expanded production by constructing an addition to the building. In 1905, the mill was sold to N.S. Perkins of Birmingham. By that time, the mill was utilizing 1,500 to 2,000 bales of cotton per day. (PLACC-RBC.)

The mill's name was eventually changed to Southern Cotton Mill (though this photograph shows the name as Southern Mills Corporation). Due to a national decline in textile production, the mill closed in the early 1980s. In 1981, the 21-acre site and 57,000-square-foot mill and warehouse were sold to Collateral Investment Company of Birmingham. From 1983 to 1997, Olde Mill Antiques Mall was housed in the complex. Olde Mill Antiques, the South's largest indoor antique mall, was owned and operated by Huey Burrows. (PLACC-RBC.)

Dreadzil P. Haynes moved to Oxford in 1883 from Clay County, Alabama, to operate a mercantile business. In the early 1900s, he purchased a lot on Depot Street (now Spring Street) from Thomas H. Barry. D.P. Haynes & Bro. was a horse and mule company. J.I. Case Threshing Co., shown in the photo, was a machine shop for farming equipment. It is apparent that Haynes sold horses and mules to the company for farming practices. (PLACC-RBC.)

Due to Oxford's location, it served as a cotton-trading hub. These two children are standing on South Main Street with the train depot in the background. At that time, the train depot was adorned with a cupola. (KBH.)

A horse-drawn buggy was the primary means of transportation for people during the early 1900s. A trolley (in the center background) is traveling south on Main Street toward Snow Street on the way to its destination at Oxford Lake. The first long-lasting electric light bulb was invented in the late 19th century, and soon after, many municipalities and communities were outfitted for electric lines. (OPL.)

On the far right is Miller and Sons, a mercantile store that was owned and operated by Lilburn B. Miller. The Miller family was also associated with undertaking, hardware, dry goods, and harness businesses in the community. (MKW.)

Choccolocco and Main Streets housed the business community in Oxford. Many of the early buildings lining both streets are still standing. Oxford Christian Church and a cotton warehouse are shown here on Choccolocco Street in the top right of the photograph. In 1921, Oxford Elementary School was constructed on the site of the old cotton warehouse. (PLACC-RBC.)

In the 1890s, Thad M. Gwin, a native of Blue Mountain, Alabama, established a mercantile business in Oxford. Gwin was a graduate of Oxford College and was later involved in many civic and social organizations in Oxford. In 1901, after operating his business on the north side of Choccolocco Street, he built a one-story brick commercial building. The store carried dry goods and all of the latest fashions in clothing and shoes. Pictured here are, from left to right, Frank Gwin, Joe Higginbotham, Sam Aderholt, Asa Allen, Thad M. Gwin, Flora Powell, Kate Cooper, Clara Wright, and Fannie Montgomery. (PLACC-RBC.)

The First National Bank of Oxford was founded in 1903 by Davis C. Cooper after a consolidation with the Bank of Oxford. The bank was built in 1883 at the corner of Main and Choccolocco Streets. In 1911, Cooper oversaw a renovation and expansion of the building in which the facade was altered with white marble to be the way it appears today, and the upper level was added. D.D. Draper & Sons established the first bank in Oxford in 1879. By 1888, Draper had merged with Cooper to create the Bank of Oxford. (TCW & PLACC-RBC)

Oxford flourished as a cotton-trading center in the post–Civil War South. J.J. Crow owned and operated the Alliance Cotton Warehouse in the early 1900s at the corner of Main and Snow Streets. At least eight cotton firms used the warehouse, and 40,000 to 60,000 bales of cotton passed through the warehouse each year. In 1952, the building was torn down to make way for a Jitney Jungle supermarket. (PLACC-RBC.)

J.J. Crow operated the Alabama United Ice Company at the corner of Spring and Main Streets. The building was constructed in 1929 and had a capacity of 10 tons of ice for sale to residential and commercial clients. (PLACC-RBC.)

Jesse F. Adams owned and operated a barbershop at the rear of the post office on the corner of Main and Choccolocco Streets until his death in 1950. Jabe C. Cox is seated in the rear chair getting a haircut by Mr. Draper. Cox was a prominent grocer in Oxford for 40 years. (HCG.)

Eugene L. Turner started Turner Dairies on Coldwater Road in 1927. The dairy farm consisted of 648 acres and produced several thousand dairy products each day for Calhoun, Talladega, St. Clair, and Cleburne Counties. Pictured here are, from left to right, C.E. Massey, L.A. Kemp Jr., O.C. Grizzard, D.C. Grizzard, James H. Kemp, Theodore Grizzard, Bud Kemp, L.A. Kemp Sr., Billy Grizzard, George Dewey (in the car), and George Kilgore (in the car). (PLACC-RBC.)

King's Service Station was located at Hale Street between Choccolocco and Snow Streets. There were three stations connected with King Motor Company—two in Anniston and one in Oxford. In the early 1950s, the station was known as the Oxford PAN-AM Service Station, Oxford Service Station, and Love's Amoco Station. (PLACC-RBC.)

The Standard Motor Oil service station was located at the corner of Main and Choccolocco Streets. The building pictured here was later replaced with a more modern facility that operated until the early 1980s. (PLACC-RBC.)

Butenschon Drug Company, located on Main Street, was opened in 1931 by Frank Butenschon. The drugstore served as a soda fountain, pharmacy, and bus stop for decades. In March 1988, Butenschon Drug Company merged with Harco City Drug in Anniston. In the above image, Butenschon is shown in the back of the store wearing a tie. (SMD & MKW)

Flowers Cleaners was owned and operated by Horace H. Flowers Sr. from the late 1930s until his death in 1979. The cleaners operated at 18 West Choccolocco Street and served Black citizens of Oxford and Hobson City. While the store was in business, Flowers served as clerk for Hobson City and later as mayor. (OPL.)

Bettie Mellon, daughter of William and Sarah Foster Mellon, operated a dog kennel at the family's home on Choccolocco Street. Mellon sold fox terriers, Boston bull terriers, chows, and chihuahuas. (PLACC-RBC.)

In 1951, plans were underway for the construction of Anniston Tube Works General Electric Company on Highway 78. The 157,000-square-foot plant opened in June 1952 and cost $6 million. When it opened, the company had hired 250 employees from 18 regional communities across northeast Alabama and west Georgia. Employment was expected to reach 2,000, with 85 percent being females. The plant received national attention after receiving applications from people across 11 states, including Wisconsin, New York, Georgia, Florida, Texas, Tennessee, Kentucky, Massachusetts, Pennsylvania, Mississippi, and Louisiana. (PLACC-RBC & ADAH)

National Gypsum, a manufacturer of building materials, was founded in 1925 by Joseph F. Haggerty, Clarence E. Williams, and Melvin H. Baker. The Oxford plant was constructed and opened in 1955 at the intersection of Coldwater Road and US Highway 78. (PLACC-RBC.)

Motel Samantha opened to the public in December 1954 as a 30-unit modern motel. Elbert P. Holmes, owner and operator, named the motel in honor of his daughter, Samantha. Advertisements for the motel stated that each room included central heating and air-conditioning, colored tile baths, television, soundproof walls, and a telephone. By 1960, the motel included 55 units, with 40 more under construction. By the late 1960s, Motel Samantha also featured a swimming pool, putting greens, a restaurant, and a playground for children. (MKW.)

In early 1962, construction began on a two-story, 60-unit Holiday Inn motel with a restaurant, convention room, swimming pool, and service station at the crossroads of Alabama Highway 21 and US Highway 78. (MKW.)

On August 17, 1970, a 330,000-square-foot indoor shopping center opened in Oxford—the Quintard Mall was a multimillion-dollar development that included 16 stores and 2,000 parking spots on 30 acres of prime property at the corner of US Highway 78 and Alabama Highway 21 (Quintard Avenue). The mall was a regional attraction that was expected to bring in between $7 million and $15 million in sales each year. (HCG.)

Five

RECREATION AND
ENTERTAINMENT

As Oxford's population grew, people began to enjoy the beautiful scenery that surrounded them. In 1833, Barnett McCulley moved to land east of Oxford that included a spring. McCulley's Spring quickly became known as a pleasant place to enjoy outdoor activities. In 1888, the Minnie Lula Lake Company bought the McCulley farm, which consisted of 30 acres, for $20,000; the property was later transferred—through a foreclosure sale of a mortgage—to the Anniston Electric and Gas Company. The company constructed a lake that covered 15–20 acres on the property with an island in the middle. Around the body of water, which was named Oxford Lake, were constructed bathhouses and other buildings that housed items related to activities such as canoe rides to the island, a horse-racing track, monkey shows, vaudeville shows, and other attractions. Oxford Lake opened to the public on May 30, 1889. People increasingly came to enjoy the beautiful area, and in 1940, Mr. and Mrs. Billy Morgan, upon leasing the land, set up amusements that included boat races, bowling, skating, a carousel, and a Ferris wheel. The Morgan family continued to lease the Oxford Lake property until 1952. The grounds and facilities were purchased by the City of Oxford in 1965 (under the administration of Mayor Alvis A. Hamric) for $117,000.

In the years since, some of the activities have been removed or replaced, and the facilities have grown to include a civic center (built in 1975), playgrounds, ball fields of many types for players of different abilities, and walking tracks. One of the oldest remaining covered bridges in Alabama, the Coldwater Covered Bridge, is located on the property and listed in the National Register of Historic Places. Liberty and Freedom Parks are both on the property, and a pool is available as well. Oxford Lake remains a centralized gathering place for the city.

While Oxford Lake has fulfilled many of the recreational needs of Oxford citizens for over a century, the city has added facilities in other areas to meet the needs of a growing community. Bannister Park and the Cheaha Clubhouse have been serving the Friendship area for decades; the Bynum Community Center and Choccolocco Park are more recent additions to Oxford's recreational opportunities. In 2013, Oxford opened a 1,200-seat performing arts center in a historic downtown building that had, over the years, housed an elementary school, city hall, and a police station.

—Amy E. Henderson

John and Willie Wardlaw Hollingsworth are pictured with their infant son Bryant in 1912 enjoying a walk around Oxford Lake. From the start of the 20th century to the present, family gatherings and picnics have been held at the lake. (HCG.)

An article from the *Anniston Star* dated July 6, 1900, described the following wedding ceremony at Matrimony Isle: "The Oxford Lake island is getting to be quite a popular place for romantic marriages. The second wedding of the summer occurred there Wednesday afternoon at four o'clock. The contracting parties were Mr. Alex Roper and Miss Sibey Evett, both of this city. The ceremony was performed by Rev. L.F. Goodwin. The groom is a popular employee of the Southern Car and Foundry company and the bride is a charming young lady and is quite popular among a large circle of friends." (PLACC-RBC.)

Oxford Lake, Anniston, Ala.

Oxford Lake, one of the area's most recognizable and notable recreational parks, opened to the public on May 30, 1889. The lake was constructed on the former site of McCulley Springs that was home to Barnett McCulley starting in the 1830s. In November 1888, descendants of the McCulley family sold the land to the Minnie Lula Lake Company for $20,000 in hopes of turning it into an amusement park. After this dream failed to be realized, Alabama Electric & Gas Company obtained the lake through a foreclosure. (OPL & MKW)

Oxford Lake. ANNISTON, Ala.

A trolley line was constructed from Twenty-Fifth and Noble Streets in Anniston to Oxford Lake. During the Victorian era, amusement parks were constructed at the end of trolley lines to coax passengers to ride the trollies. In those early years, the park at Oxford Lake spanned nearly 20 acres and included a swimming pool (pictured above and below), horse-racing track, dance pavilion, and vaudeville theater (this was later converted to a bowling alley). Along with the entertainment and recreational amenities, families and young couples could enjoy leisurely walks and picnics around the lake. (MKW.)

In 1900, advertisements appeared in local publications promoting Oxford Lake as having the only swimming pool in the area. In 1902, the existing pool at the lake, which was built of wood, was removed to make way for a more modern pool made of concrete with an adjoining bathhouse, slide, and diving platform. The pool was available for use at no cost. This postcard image shows visitors swimming and playing in the concrete pool. (MKW.)

The dance hall, pictured here in the early 1900s, was a popular spot for young courting couples to spend their evenings. In the mid-1960s, the hall was destroyed by a fire. (PLACC-RBC.)

Among the many activities available to visitors in Oxford Lake's heyday was the bowling alley with six lanes. In 1968, the building was destroyed by fire. Oxford Lake was a hub of recreation and activity for Calhoun County residents for many generations. (PLACC-RBC.)

In an undated note and postcard (pictured above) included in the Bessie Coleman Robinson Collection at the Public Library of Anniston–Calhoun County, a visitor to Oxford Lake wrote: "But the excitement of the day to a four year old was a trip to Oxford Lake. The lake itself spelled magic to our minds but the biggest thrill was in the street car ride." (MKW.)

The boathouse at the lake offered visitors the ability to take small passenger boats out to the island for 25¢ per hour. The boathouse was torn down in 1978. (MKW.)

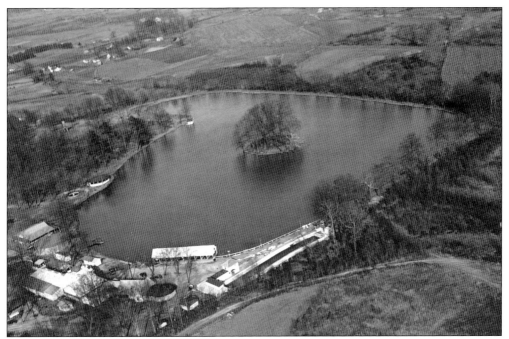

This aerial view of the Oxford Lake area shows the entire recreation complex. Most notable in the photograph are the rectangular swimming pool, boathouse, and island. (PLACC-RBC.)

This aerial view of Oxford Lake shows the shape of the lake and the proximity and size of the island at its center. In the 1960s, due to erosion, the island decreased in size. The oak trees located on the island were eventually destroyed by a large number of beavers. (PLACC-RBC.)

The two children pictured here are all smiles as they enjoy one of the two carousels at Oxford Lake in the 1940s. Billy Morgan and his wife, who owned the park at that time, brought in special attractions to entertain visitors of all ages at the park. (OPL.)

The 1940s and 1950s were perhaps the most prosperous period of the park since its opening. Billy Morgan and his family leased the lake and surrounding property and resided in the large home that overlooked the lake. The home was used as a hotel at one time and is rumored to have been constructed on the former located of a Confederate campsite. The Morgans transformed Oxford Lake into a carnival boardwalk venue with powerboat races, a Tilt-A-Whirl, a petting zoo, and a merry-go-round. (OPL.)

Louis Henderson, resident caretaker of animals at the lake, is shown with a few of the deer held in captivity there. Henderson started working and living at Oxford Lake in 1961 after retiring from Anniston Ordnance Depot. In addition to deer, he also tended to swans, ducks, alligators, and a fox and collected Native American artifacts he found on the grounds. (PLACC-RBC.)

In both of these images, young children are shown enjoying some of the recreational opportunities at the lake. The Billy Morgan family installed many children's rides and games on the property. In 1955, the decline in the condition of the park led to the Morgans selling everything to other venues across the country. (PLACC-RBC.)

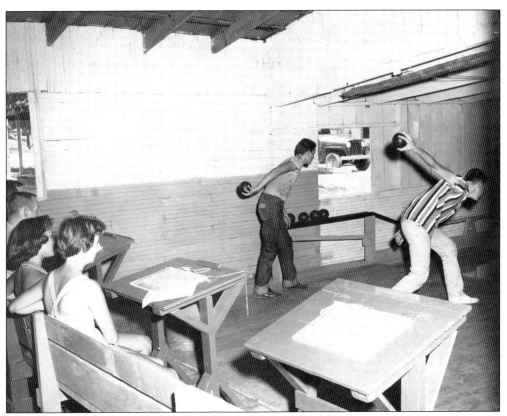

A group of teenagers is shown bowling as their friends watch. The lake was a popular spot for young adults to spend their free time. The bowling alley, which was installed in the late 19th century, was destroyed by fire in 1967. (PLACC-RBC.)

The Ferris wheel was a popular attraction during the time the Billy Morgan family managed Oxford Lake. Pictured here in the 1970s, it was installed in the 1940s, when the Morgans added many attractions. The Ferris wheel and the merry-go-round were sold to Jack Blanton of Heflin in 1977 in a city surplus auction. Blanton intended to "put it on my farm and use it" for neighborhood children. (OPL.)

During Mayor Alvis A. Hamric's administration, he detailed nine goals for 1965. Included in that outline was the purchase of Oxford Lake. Later that year, in September 1965, the City of Oxford purchased the property for $80,000. Today, the park includes a walking track around the perimeter of the lake, a number of pavilions, a complex of baseball and softball fields, a state-of-the-art civic center, and even Alabama's oldest covered bridge. (OPL.)

Felton "Skipper" Snow, son of Jonah and Claudia Johnson Snow, was born on October 23, 1905, in Oxford, Alabama. When he was young, his family moved to Louisville, Kentucky. Snow played professional baseball for the Nashville Elite Giants, Washington Elite Giants, and Baltimore Elite Giants. Snow is pictured here in the 1940s with several of his Baltimore Elite Giants teammates—from left to right are Henry Kimbro, Bill Byrd, Snow, and George Scales. (TU.)

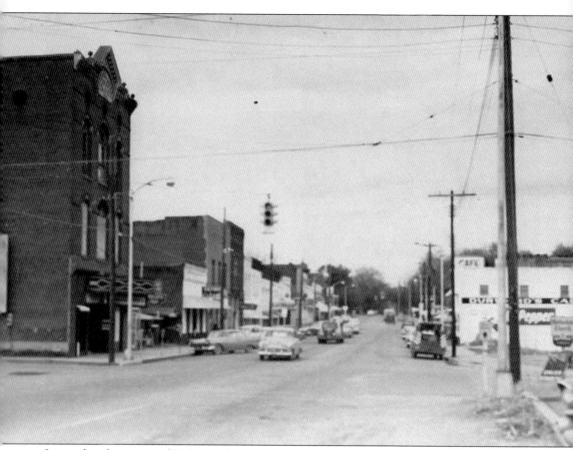

Located at the corner of Spring and Main Streets, the Oxford Theater was constructed in 1892. From the time of the building's construction until the 1930s, Rathbone Lodge No. 68 of the Knights of Pythias occupied the upper level. In later years, the lower level was used as a grocery store and telephone exchange. From 1941 until 1956, Hill Powell operated the Oxford Theater in the building. In 1964, the building was torn down. (PLACC-RBC.)

Six

Around the Town

When Oxford was founded in 1852, the town limits encompassed the nucleus around the male academy at Second Street. After decades of continued growth for Oxford, the city began to annex and incorporate neighborhoods and communities that had existed since the time Oxford was established.

Bynum, located west of Oxford, was referred to as Pig Tract in the early years due to the vast amount of pig farms in the area. Eli Bynum came to Benton County from Blount County in the 1830s and established a large farm. After Eli's death in 1876, his son, Eli Bynum Jr., inherited 1,000 acres and eventually passed the land to his son, Tapley D. Bynum. When the Georgia Pacific Railroad began coming through the area, he agreed to the right-of-way access with the condition that the stop be named for his family.

Eastaboga, located west of Oxford on the Talladega and Calhoun County lines, was named McFall until June 29, 1923. Eastaboga is a Creek word derived from *isti*, meaning people, and *apoga*, meaning dwelling place. It was also referred to as Shakerag. A post office was established there in 1854.

Coldwater, located west of Oxford, was established by Chesley Hughes around 1834. The name is derived from the nearby creek that constantly flows with cold water. A post office was established here in 1879 and originally called Marthadell; the name was changed to Coldwater in 1894. The post office was discontinued in 1907.

DeArmanville, located east of Oxford toward the Choccolocco Valley, was established by John W. DeArman around 1833. It is said that DeArman traded ponies for the land between Oxford and White Plains with Chief Oconee. The area was originally called Center but had to change this due to another nearby town with the same name. It was named DeArmersville in 1873, when a post office was established there, and changed to DeArmanville in 1878. Hudson H. Allen was an early permanent resident in the area. Both the DeArman and Allen families held stock in the railroad that passed through their lands.

Other unincorporated communities in Oxford included Boiling Springs, Hicks, Friendship, Knoxville, Lardent, Trinity, and Boozerville. Boiling Springs was named for a continuously flowing spring; a post office was established there in 1846 and discontinued in 1854. Hicks is named for the Hicks family that purchased 100 acres in the area in the 1960s. Friendship is named for the friendliness of the people there. Knoxville is a community of predominantly Black families—specifically, the Knox family. Lardent was named by the railroad for the area between Anniston and Oxford. Trinity is named for the church and school established in that area. Boozerville, located in the southern portion of Oxford, is named for Judge Simon E. Boozer, who owned the land.

—Hunter C. Gentry

The Coldwater Covered Bridge, constructed about 1850 with the use of the labor of enslaved people, spanned 63 feet across Coldwater Creek. In August 1920, the bridge partially burned but was saved and restored for vehicle traffic. After it was decommissioned, the bridge was replaced in 1974. In 1990, local efforts were successful in relocating the bridge to Oxford Lake Park. The bridge is listed in the National Register of Historic Places. (PLACC-RBC.)

The Boiling Springs Road Bridge, locally known as Hell's Gate Bridge, was constructed around 1930. The bridge connected the Boiling Springs community to the Friendship community and was built in the fashion of the popular iron truss bridges of the time period. For nearly half of a century, a local legend claimed that the bridge is haunted. It is stated that if one is to walk or drive onto the bridge at night and look over their shoulder, the fiery pits of hell appear—hence the local moniker. This legend seems to have been popularized after the death of a young couple sometime in the 1950s. Another legend suggests that if a person drives over the bridge at night, a wet spot will appear on one of the seats. Due to rapid increases in traffic and the construction of homes, as well as the growing populations of the surrounding neighborhoods, Leon Smith Parkway bypassed Boiling Springs Road in 2005. (OPL.)

William E. Mellon, son of William and Esther Reid Mellon, established the Mellon Apple Orchard in 1896. The farm and orchard were located east of Oxford and adjacent to Mellon's father's farm, which was located near Buckelew Bridge Road and Mellon Bridge Road. It included eight acres with 400 apple trees. Sam Mellon, son of William E. Mellon, is pictured here with the orchard in full bloom. (SMD.)

Mellon Covered Bridge, constructed in the late 1800s, spanned nearly 100 feet across Choccolocco Creek. After the bridge was decommissioned, plans were made by the Oxford Jaycees to relocate the bridge to a park. Those plans were abandoned after an arsonist burned the bridge in the fall of 1970. (PLACC-RBC.)

Hartwell Masonic Lodge No. 101 was established on February 6, 1849, under the leadership of W.L. Cunningham as Worshipful Master. Members of the lodge originally gathered in the upper level of a wooden building on Main Street, then in the upper level of the Oxford Hotel before it burned down in the 1880s. In 1891, members of the lodge purchased a building on the northwest side of Main Street for $3,045.51. The lodge relocated to its present site in the spring of 1971, and the building shown here was eventually torn down. (HML.)

In September 1919, members of the Fort Strother chapter of the Daughters of the American Revolution dedicated the Gen. Andrew Jackson Memorial at Simmons Park. Mayor Davis C. Cooper is standing on the right side of the marker. Simmons Park was on land donated by Elisha S. Simmons for the city to use as a public park before he moved to Texas in the 1850s. During the Reconstruction era, the park was used as a meeting place for cotton traders. (TCW.)

In 1875, the first horse-drawn streetcar traveled from Oxanna to Oxford. After the creation of Oxford Lake in the late 1880s, Alabama Power worked to add an electric trolley line from Anniston to Oxford Lake. The line ran from Noble Street in Anniston to Main and Snow Streets in Oxford and ended at Oxford Lake. An advertisement from the *Anniston Star* from 1923 noted that the trolley "was the safest and most economical way going to Oxford Lake Park." (OPL.)

The legend of Blue Pond is a familiar folk story passed from one generation to another in Oxford. Blue Pond is currently nestled in a residential neighborhood on the eastern side of Oxford. The earliest reference to the local folklore dates to 1890 and appeared in the *Newton Enterprise* (Newton, North Carolina), *Wyoming Democrat* (Tunkhannock, Pennsylvania), *Burrton Weekly* (Burrton, Kansas), and *Dispatch* (Hope, Kansas). All of these papers ran articles that year entitled "Devil's Lake in Alabama." In 1896, Charles M. Skinner published a book titled *Myths and Legends of Our Own Land*; the chapter called "The Swallowing Earthquake" is a reference to Blue Pond. The publication states that a Native American village stood near the present site of Oxford around 1765. Two women in the tribe gave birth to a number of children who were "spotted like leopards." The article states that a woman was "charged with witchcraft, convicted and sentenced to death at the stake." A gathering of approximately 1,700 watched the execution. As the tribe was carrying out the execution, legend holds that an earthquake caused the ground to sink and fill the resulting hole with water, and the whole village was engulfed. (PLACC-RBC.)

It was customary and traditional for the Cooper family to gather each year for the sharing of a tree at Christmas. Members of the family are shown here at the home of Charles J. Cooper on Christmas in 1902. (KBH.)

In May 1901, to celebrate the carnival season, Anniston, Oxford, Gadsden, and Talladega worked to present a parade in Anniston. The *Anniston Star* stated: "The difficulty in making a selection was considerable, as Oxford and Talladega both had magnificent floats in the parade. The Oxford float represents a graceful boat and was exquisitely beautiful. On it there had been much faithful work and the result was pleasing not only to those who had helped make the float beautiful, but to the thousands of spectators who saw it." (PLACC-RBC.)

The Rainbow Inn was located on US Highway 78 a few miles east of Oxford. It primarily served as a truck stop for travelers going between Birmingham and Atlanta. Charles C. Knight owned and operated the Rainbow Inn from the 1940s until the 1980s. (SMD.)

During the 1930s and 1940s, street photography was popular. Though this particular image is not an official "street photograph," it shows the styles of the time. The unknown subject is walking along Choccolocco Street. The Oxford Motor Company traded and sold Ford vehicles and tractors from its location at Choccolocco Street for a number of decades. (SMD.)

Sam Mellon Jr. and Willard Pottard are pictured from left to right with a mule and plow in the field at the Mellon farm and orchard in DeArmanville. Pottard was the grandson of Lawson and Henrietta Caver Jones. (SMD.)

This is a 1950s aerial view of Oxford. Most notable among the landmarks are the Oxford Theatre, Oxford City Hall, Hartwell Masonic Lodge No. 101, and First Baptist Church of Oxford. (OPL.)

Seven

NOTABLE CITIZENS

For thousands of years, the Indigenous members of the Muscogee Creek tribe called this area home. By 1830, Alabama had around 300,000 residents, with one-fifth of that number consisting of enslaved peoples. That year, Congress passed the Indian Removal Act to force Native Americans to move west of the Mississippi River. For a time, however, European settlers and Native Americans cohabited with one another in the Oxford area. Many accounts of Oxford's early European arrivals tell of peaceful trade and interactions with the Indigenous peoples. In 1832, under the direction of Pres. Andrew Jackson, Muscogee Creek natives were forcibly removed to present-day Oklahoma along a track known as the Trail of Tears.

In 1880, the population of Oxford was 780. By 1890, the population had nearly doubled. Over the course of a few decades, the population declined, most likely due to the industrial boom in nearby Anniston. In 1960, the population of Oxford hit an all-time high (to date) with 3,603 residents. Since 1960, Oxford's population has rapidly increased due in no small part to its proximity to highways and the interstate, as well as a boom in retail commerce. Today, Oxford boasts a population of over 21,000 residents.

—Hunter C. Gentry

Elbert Harrison Allen (1825–1883) was one of Oxford's first physicians. His father, Matthew Allen, brought the bill to the Alabama House of Representatives to incorporate Oxford as a town. During Elbert's time as a physician, Oxford greatly benefited from his knowledge and practice of medicine. (TCW.)

Eliza Harrison Campbell (1831–1912) was, at one point, enslaved by William Harrison. She worked as a cook for most of her adult life and married James Campbell. She was buried in Oxford Memorial Gardens Cemetery near the grave of William Harrison. (HCG.)

John LaFayette Dodson (1837–1911) was the founder of Oxford College and also served as a professor and president there. He received his formal education from Davidson College in North Carolina but was unable to graduate due to the outbreak of the Civil War. After the war, he moved to Oxford and worked with William J. Borden to establish Oxford College. Dodson taught at Jacksonville, Spring Garden, Lincoln, and Ethelsville after the college closed in 1899. Before his retirement, he served as the secretary of the Alabama State Board of Examiners for Teaching Licenses. (PLACC-RBC.)

John Floyd Smith (1839–1931) was a merchant, farmer, and veteran. Smith inherited the Caver family farm in Boiling Springs after the death of his father-in-law, Thomas J. Caver. During the summer months, the family resided there; in the winter months, they lived at their home on Gray Street. Smith served in the Confederate Army under Col. John H. Forney and was wounded three different times in battle. (OPL.)

LaFayette Hoyt Smith DeFriese (1852–1928) suffered the death of both of his parents at an early age. He was granted a license to teach by the age of 12. He received degrees from Oxford College, University of California, and Harvard University. DeFriese practiced law in New York and the Supreme Court, and he worked as a private counselor to Queen Victoria of England. (HCG.)

Robert P. Thomason (1852–1910) served as mayor of Oxford during the late 1880s, when Oxford Lake opened as the area's first amusement park. He was also a merchant. (OPL.)

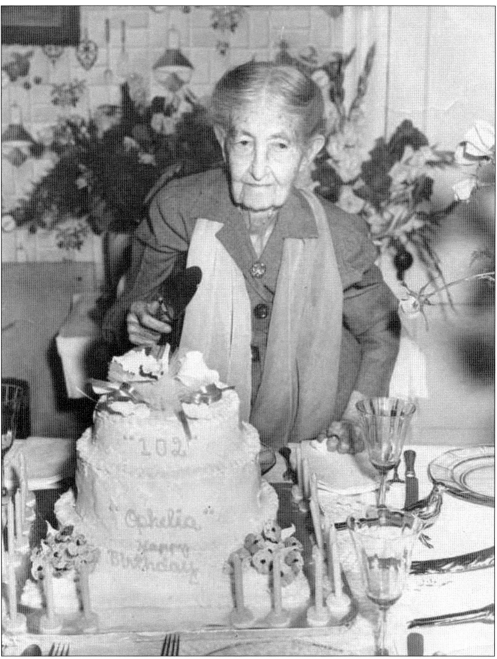

Nancy Ophelia Victoria Allen Aderholt (1854–1958) was, at one time, the oldest living citizen of Oxford. She was the daughter of Rev. Asa and Serena Cunningham Allen. Aderholt lived through the Civil War, the Spanish-American War, World War I, World War II, and the Korean War. During her life, she saw many advancements in technology and changes in Oxford. (HCG.)

Isaac Gaston worked as a butler for Mayor Davis C. Cooper. He resided with the Cooper family at 301 Main Street. (PLACC-RBC.)

Oliver Winston Cooper (1856–1920) was a cotton trader and one of Oxford's leading businessmen during the late 19th century. He was the older brother of Mayor Davis C. Cooper and son of Charles Jefferson Cooper and a member of Oxford Christian Church. He is shown seated on the left, with two members of his family. (KBH.)

Thad M. Gwin (1858–1944) owned and operated Thad M. Gwin & Co. Dry Goods store for decades. He was a merchant in the area for 67 years. Gwin was a member of Oxford's First Baptist Church and served as a deacon for 40 years. Mr. and Mrs. Gwin are pictured here at their home on Main Street for their 50th anniversary. (PLACC-RBC.)

John Nathan Gunnels (1861–1932) served as a one-term mayor in the early 1890s. He was the son of an early resident and merchant, Daniel P. Gunnels. (OPL.)

Davis Clay "D.C." Cooper (1866–1943) served as mayor of Oxford from 1910 to 1929. At an early age, Cooper went into business with his father, Charles Jefferson Cooper, and later organized the Bank of Oxford, where he served as president. He also served on the Oxanna and Anniston City Councils, Oxford Board of Education, and was a trustee of Howard College in Birmingham. Cooper was a devout follower of the Baptist faith, a member of Oxford's First Baptist Church, and served on the Calhoun Baptist Association, Alabama Baptist State Missions Board. Additionally, he held offices of the Grand Lodge of the Knights of Pythias and Grand Chancellor Commander, Supreme Council, and Master of the Oxford Masonic organization. (HCG.)

Elbert "Tull" Allen (1869–1912), pictured seated on the top step, worked as a cashier at First National Bank of Oxford for his uncle, Davis C. Cooper. Allen was the son of Dr. Elbert H. Allen and a member of the First Baptist Church of Oxford. (TCW.)

Thomas Gaines Roberts (1870–1941) was an 1890 graduate of Oxford College. Roberts held five degrees from several higher learning institutions. He served as an American lawyer in France and a US Navy captain during World War I, and he oversaw the construction of 136 naval warships. (SMD.)

Elder Caver (1887–1961) was a descendant of people enslaved by Thomas J. Caver of the Boiling Springs community. For most of his life, Elder Caver worked as a tenant farmer on the lands on which his ancestors were forced to labor. Elder received a fourth-grade education and was a veteran of World War I. (PLACC-RBC.)

Frank Butenschon Sr. (1887–1974) was the owner and operator of Butenschon Drug Company. He was educated in Anniston City Schools and graduated from Vanderbilt University. Butenschon was the city clerk under the Davis C. Cooper administration and was involved with the Oxford Chamber of Commerce and Lions Club. (PLACC-RBC.)

Maud McLure Kelly (1887–1973) was the first female to practice law in Alabama. She was the granddaughter of Samuel C. Kelly, former mayor of Oxford during the 1870s. Kelly worked to ensure women's suffrage and was an advocate for the underserved and poor. Before her death, she worked at the Alabama Department of Archives and History. (ADAH.)

Thomas Blake Howle (1893–1973) graduated from Calhoun County High School and Auburn University. During World War I, he served the US Army by buying livestock. Howle served as Oxford's mayor from 1932 to 1936 and 1940 to 1944. In 1947, he was elected to serve in the Alabama Senate. Howle is pictured above, standing second from left, with fellow Auburn students. (NLW.)

Herman Tyndall "H.T." Stanford (1896–1985) served for 30 years as principal of Oxford High School. He was a member of the First United Methodist Church of Oxford and many civic organizations. In 1975, he was recognized by the Oxford Kiwanis Club as "Man of the Year." (PLACC-RBC.)

Georgia Pyles Ellison (1897–1949) worked at the Oxford Lake swimming pool for 30 years. Ellison was a native of Hobson City. (SMD.)

Robert Russell Pope (1897–1973) was mayor of Oxford from 1930 to 1932. During his time in office, streets were paved, the city cemetery was improved, and streetlights were added in residential areas. (OPL.)

James Lovett Nease (1903–1958) was a longtime teacher at Oxford High School. Nease was a graduate of Emory University and started teaching at Oxford High in 1925. It is estimated that he taught more than 4,000 students over the course of his career. (PLACC-RBC.)

Hemphill Gay "H.G." Whiteside (1906–1986) served as mayor of Oxford from 1944 to 1960. He was a descendant of several European families who settled in the area. Whiteside was a graduate of Calhoun County High School and North Georgia Agriculture College. (WF-BGWC.)

Robert Andrew Hingson (1913–1996) was world-renowned for his breakthrough work in anesthesiology and immunization from smallpox for millions of people in Liberia. Hingson was a pioneer in medicine due to introducing caudal and epidural anesthesia. (PLACC-RBC.)

William Francis Roberts (1917–1941) served in the US Navy during World War II aboard the USS *Arizona* at Pearl Harbor in Hawaii. During the attack on Pearl Harbor on December 7, 1941, he sacrificed his life. (TC.)

Howard Bentley (1920–1997) owned and operated Oxford Dry Cleaners from 1946 until his death. The cleaners is the oldest continuously operating business in downtown Oxford. Bentley served in the Navy during World War II and as a council member during the H.G. Whiteside administration. He was also a member of Hartwell Masonic Lodge No. 101, the American Legion, and the First Baptist Church of Oxford. (KBH.)

Earl Martin (1924–1982) served as mayor of Oxford from 1980 to 1982. He attended the University of Alabama on a baseball scholarship. Martin was briefly employed as a teacher and later worked for General Motors in Birmingham. He was a professional baseball player and was the first director of Oxford Parks and Recreation. (OPL.)

Oscar Cotton (1926–2002) was a minister and businessman. Cotton served in the US Navy during World War II and later worked at Kilby Steel and the Anniston Army Depot. He served as pastor in churches across the region for 50 years. After working for Landers Furniture in the 1960s, Cotton purchased the downtown business. He was also a charter board member of the Independent Bank of Oxford. (NCB.)

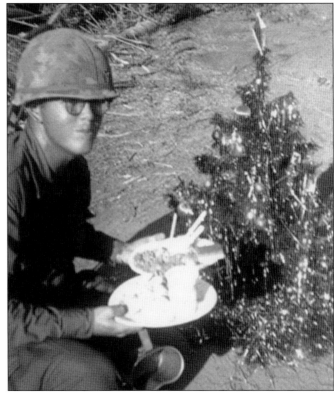

Willard Frank Young (1946–1968) graduated from Oxford High School in 1964. In 1966, he was drafted into the US Army to serve in Vietnam. He died in Gia Dinh, Ho Chi Minh, Vietnam. (CYH.)

Eight

MUNICIPAL GOVERNMENT

Oxford was established by an act of the Alabama Legislature on February 7, 1852. The bill was proposed by Rep. Matthew Allen of Benton County. The limits of the town extended one square mile from the center at the male academy on Second Street. Elisha S. Simmons, Edmund P. Gains, John A. Turnipseed, Stephen C. Williams, and Woodson Seay were authorized to run on a ballot for the election of three council members and an intendant (mayor). It was decided that on the first Saturday of each March, municipal elections would be held for the offices of council members and mayor.

On February 21, 1860, Oxford was chartered for the second time due to the redrawing of boundary lines and changing the name of Benton County to Calhoun County. The limits of the town included a half-mile in each direction from the railroad culvert at Spring Street. Elections were to be held on the first Monday of each March. In this incorporation, the law called for the election of seven councilmembers and an intendant. The councilmembers and intendant were given the power to elect a marshal, clerk, and treasurer.

Those who have served as mayor of Oxford include, respectively, Elisha S. Simmons, Dr. Stephen C. Williams, Samuel C. Kelly, James S. Kelly, Edgar H. Hanna, Charles T. Hilton, William J. Borden, John B. McCain, Dr. Thomas C. Hill, Robert P. Thomason, William H. Griffin, John N. Gunnels, Thomas A. Howle, Maj. William A. Orr, George W. Eichelberger, William C. Gray, Dreadzil P. Haynes, Asa C. Allen, William R. Norton, Davis C. Cooper, Robert R. Pope, Dr. Thomas B. Howle, Carl D. Pace, Hemphill G. Whiteside, Alvis A. Hamric, Bester A. Adams, Earl R. Martin, Therman E. Whitmore, Leon Smith, and Alton Craft.

The Oxford Police Department was established at the time of the first incorporation. However, the earliest police force included just one town marshal. The first recorded marshal for Oxford was Francis M. Gardner, who served in the early 1880s. The Oxford Fire Department was organized on May 18, 1884, as a volunteer department. Maj. William A. Orr served as the first chief.

In 1904, the citizens of Oxford were convinced that the town needed a permanent city hall for the purposes of conducting municipal business. In September of that year, it was decided that city hall would be located in a building on Main Street, and the fire department would share the building. An armory was established adjacent to the building for the Calhoun Rifles. The calaboose was located several yards south on Spring Street.

—Hunter C. Gentry

William Anderson Orr served as Oxford's first fire chief and as mayor during the 1890s. He was the son of James and Emma Lester Orr and was born on July 23, 1855, in Talladega County, Alabama. He was a member of Dodson Memorial Presbyterian Church and Hartwell Masonic Lodge No. 101. (OPL.)

The Katie G. Fire Wagon was the first horse-drawn wagon used by the Oxford Fire Department. George (the horse) and three human members of the fire department are pictured outside of Parker Memorial Baptist Church at Quintard Avenue and Twelfth Street in Anniston. The Oxford Fire Department still owns the bell that is shown on the wagon. (PLACC-RBC.)

The *Hot Blast*, the predecessor to the *Anniston Star*, recorded on March 14, 1885, that the Oxford Fire Department purchased a fire alarm bell. The bell was used to alarm citizens during times of distress, especially on the occasion of a fire. Today, the bell sits in the cupola atop the Oxford Performing Arts Center. On at least four occasions, the Oxford Fire Department saved the town from burning to the ground due to a fire within the Oxford Hotel. In 1883, 1885, 1888, and 1890, the Oxford Hotel caught fire. On December 8, 1885, Maj. William A. Orr fell from the roof of the hotel and broke his hip while trying to stop the blaze from spreading to nearby buildings and residences. (HCG.)

In October 1959, the City of Oxford purchased a new 500-gallon booster tank fire truck from King Motor Company. The truck was the second one purchased by the city since 1943. Pictured from left to right are Mayor Hemphill G. Whiteside, Fred Nunnally, assistant chief Artis H. Prestridge, chief Samuel O. Higginbotham, and Burnette Lee at Oxford City Hall on Choccolocco Street. (PLACC-RBC.)

113

William C. Borders served as the Oxford police chief during the 1930s. Borders was born in DeArmanville, Alabama, on January 29, 1859, to Abner and Sarah Griffin Borders. He was the grandson of John and Cynthia Knox Borders, early settlers in the Choccolocco Valley. (PLACC-RBC.)

Fannie McClellan Jenkins, daughter of Edgar and Adella Hill Jenkins, served as one of the first female officers for the Oxford Police Department in the late 1950s and early 1960s. Jenkins received her education at Clay County schools and Jacksonville State University. She was a schoolteacher, postmaster, and member of the Oxford Church of Christ. (OPD.)

Oxford police captain William H. Beard began working for the department in the early 1960s. In the above photograph, Mayor Alvis A. Hamric is pinning Captain Beard. In the below photograph, Beard is taking an accident report for a vehicle crash on Hale Street. In August 1977, Captain Beard was killed in the line of duty while transporting a prisoner. Beard was a member of Meadowbrook Baptist Church and Oxford Lions Club. (OPD.)

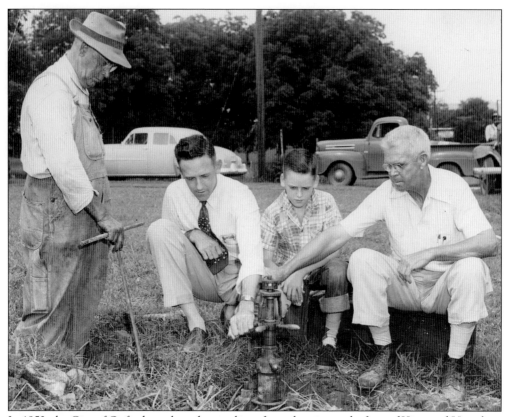

In 1953, the City of Oxford purchased water lines from the pipeworks firm of King and Hamilton of Anniston for residences from Monger and Choccolocco Streets east along US Highway 78 to McCullars Lane and south to Oxford Lake. Former mayor Carl D. Pace is on the far right. (PLACC-RBC.)

Mayor Hemphill G. Whiteside (standing fourth from right) is shown with city and state officials. From the mid-1940s until 1960, Oxford saw much progress in terms of public utilities and infrastructure. (OPL.)

Under the leadership of Mayor Hemphill G. Whiteside, Oxford City Hall moved to 100 Choccolocco Street in June 1952. The building, which previously housed Oxford Elementary School, was purchased for $20,000 and updated to include offices for the city clerk, mayor, police department, fire department, water department, and municipal court. (OPL.)

On June 10, 1953, Gov. Gordon Persons, alongside a group of Oxford residents led by Mayor Hemphill G. Whiteside, signed a bill to annex the Lakeview community into the city limits of Oxford. The annexed area included half of a square mile and more than 450 residents. (PLACC-RBC.)

The Oxford Public Library, with origins that can be traced to before 1900, began by rotating through houses of prominent community residents. The location pictured here is on Snow Street, where the library was located for several years; the building also housed a local Girl Scout troop when the library vacated it in favor of a newer location. In 1979, the library moved to 213 Choccolocco Street, which had previously been the Oxford Church of Christ. The library moved to its current location in 2009. (PLACC-RBC.)

Since 1957, Oxford High School students annually observe Student Government Day, an occasion when seniors run for office and spend the day shadowing the mayor, council members, and department heads. Pictured here from left to right are "council members" Robert Nicholson, Audrey Higgins, Joan Harris, Barbara Meads, Gail Williams, and "mayor" Wayne Sparks. (PLACC-RBC.)

Assistant fire chief Artis H. Prestridge (right) is shown with students Robert Crow (center) and Billy Anderson demonstrating how to use an extinguisher. Crow was elected by his peers to be the fire chief for the day, and Anderson was a firefighter for the day. (PLACC-RBC.)

Alvis A. Hamric served as mayor from 1960 to 1970. Hamric, the son of Jared and Hester Upton Hamric, was born on January 29, 1905, in DeKalb County, Alabama. He received his formal education from Jacksonville State University and Auburn University. Before moving to Oxford in 1943, Hamric and his wife, Rubye Hyatt Hamric, taught school at White Plains. In 1946, Hamric became a public accountant at Hamric & Hudson Accountants. During his time as mayor, Oxford saw many changes, including the construction of Interstate 20 and the Quintard Mall and the extension of Blue Pond Shopping Plaza. It was also during his time in office that the mayor became a full-time city employee, Oxford Lake was purchased, and land was annexed. Before his death in 1970, Mayor Hamric worked tirelessly to ensure the creation of an independent school system for the city. (OPL.)

Construction of Interstate 20 began in the 1960s, during Mayor Alvis A. Hamric's administration. The construction and completion of the highway completely changed the economy and commerce of Oxford and its surrounding municipalities. In the fall of 1977, the 26-mile stretch from Oxford to Villa Rica, Georgia, was completed. Mayor Bester A. Adams Jr.— along with Alabama governor George Wallace and Georgia governor George Busbee—celebrated the occasion at a ribbon-cutting ceremony. (OPL & TAS)

Bester A. Adams Jr. served as mayor from 1970 to 1980. Adams, the son of Bester A. Adams and Lillie Hughes Adams, was born in Oxford on February 16, 1926. He was educated in the Oxford City School System and earned a degree from Jacksonville State University. He taught at Oxford High School and served on the city council. Adams was a local historian who authored several publications on local history. During his time in office, he and the council increased the city's operating budget, upgraded many recreational facilities, renovated the public library, and oversaw a boom in industry throughout Oxford. (AS.)

In 1970, Mayor Bester A. Adams Jr. presented a key to the city to the founder and owner of KFC, Col. Harland Sanders. Sanders was a native of Henryville, Indiana, and briefly lived in North Alabama. He was married to Josephine King of Jasper, Alabama. (SMD.)

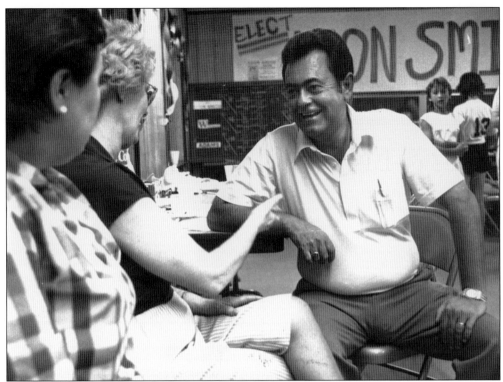

Mayor Leon Smith, a native of Tennessee, moved to Oxford in the 1960s and was a self-made businessman. Smith was sworn in as mayor of Oxford in November 1984 alongside his beloved wife, Delone, by city attorney John Phillips. Smith remained in office until 2016 and was the longest-serving mayor of Oxford; he worked tirelessly to make the city what it is today. During his time in office, the city's operating budget increased more than at any time in the city's history, retail and commerce boomed, and the population nearly tripled. (AS.)

Nine

CENTENNIAL CELEBRATION

From May 29 through June 4 in 1960, the City of Oxford observed the centennial of its second incorporation. The weeklong festivities were sponsored by the city, Oxford High School, various industries, area churches, and the Inter-Club Council—composed of the Europa Club, Quest Club, Cydonia Japonica Garden Club, Azalea Garden Club, Lakeview Garden Club, Forest Hills Garden Club, Cheaha Acres Garden Club, Lions Club, Eastern Star, American Legion Post 111, Boozerville Home Demonstration Club, Pace Circle Demonstration Club, Hartwell Masonic Lodge No. 101, Cheaha Acres Women's Club, and L'amica Club.

The committee in charge of the planning and execution of the 100th anniversary celebration included Robert Lamar, Catherine Whitehead, Hal F. West, Mrs. H.E. Nettles, and Mrs. M.J. Williams. The event started on Sunday with worship services at the Baptist, Methodist, and Presbyterian churches; Monday included a historic tour of the city; Tuesday was designated as Industry Day and concluded with a downtown street dance that evening; Wednesday was Oxford Lake Day; Thursday was Old Timer's Day, followed by a parade, dinner, and fashion show; Friday was Pioneer Days, with merchants holding special sales and promotions; and Saturday featured a pageant and the premiere of *The Curtain Rises*.

—Hunter C. Gentry

Lee Williams served as the official photographer for the Oxford Centennial Celebration. During the weeklong event, he photographed hundreds of scenes and thousands of participants. His collection of photographs was published in a commemorative booklet. (OPL.)

From left to right, J.C. Lindley, president of Oxford Lions Club; Logan Taylor, president of Oxford Little League; and Mayor Hemphill G. Whiteside are shown at Oxford Little League Park in May 1960. (OPL.)

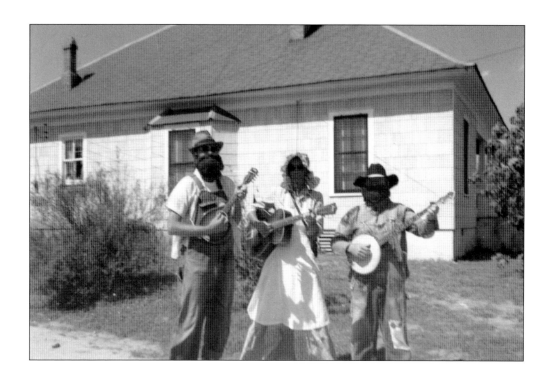

Various groups of string bands participated in the celebration. The above image shows a group in front of a home in Oxford. The other photograph is of a group performing on the corner of Choccolocco and Main Streets. (PLACC-RBC.)

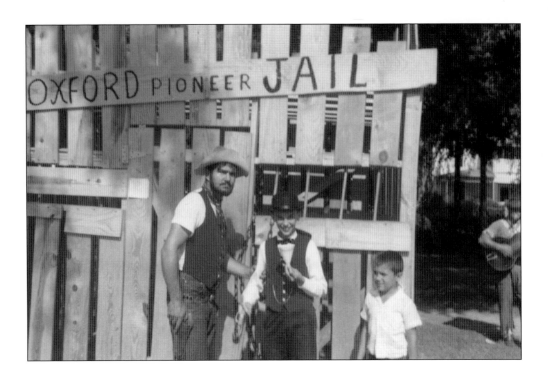

A pioneer jail was constructed at Simmons Park for the weeklong celebration of Oxford's centennial in 1960. The jail served as a popular photo opportunity spot for attendees at the festival. The Simmons-Miller-Haynes House is visible in the background of these images. (PLACC-RBC.)

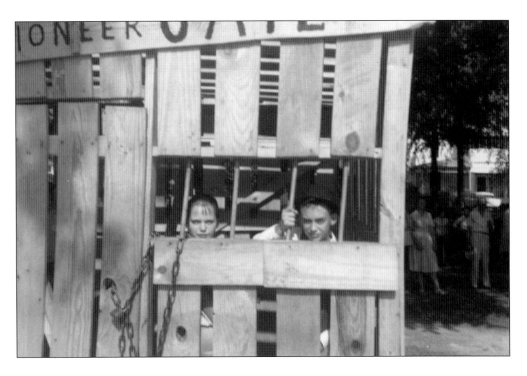

A young pair dressed in pioneer clothing is shown in front of a business on Main Street. People of all ages were urged to participate in the weeklong centennial celebration of Oxford's second incorporation. (PLACC-RBC.)

On the evening of Saturday, June 6, 1960, Mayor Hemphill G. Whiteside crowned his daughter Gay Whiteside as queen of the royal court and Billy Prestridge as king of the royal court. Gay Whiteside was sponsored by the Oxford Europa Club, and Prestridge was sponsored by the Azalea Garden Club. There was an estimated attendance of over 5,000 people at the crowning. (WF-BGWC.)

DISCOVER THOUSANDS OF LOCAL HISTORY BOOKS
FEATURING MILLIONS OF VINTAGE IMAGES

Arcadia Publishing, the leading local history publisher in the United States, is committed to making history accessible and meaningful through publishing books that celebrate and preserve the heritage of America's people and places.

Find more books like this at
www.arcadiapublishing.com

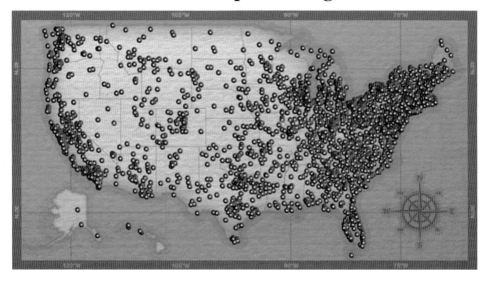

Search for your hometown history, your old stomping grounds, and even your favorite sports team.

Consistent with our mission to preserve history on a local level, this book was printed in South Carolina on American-made paper and manufactured entirely in the United States. Products carrying the accredited Forest Stewardship Council (FSC) label are printed on 100 percent FSC-certified paper.

MADE IN THE
USA